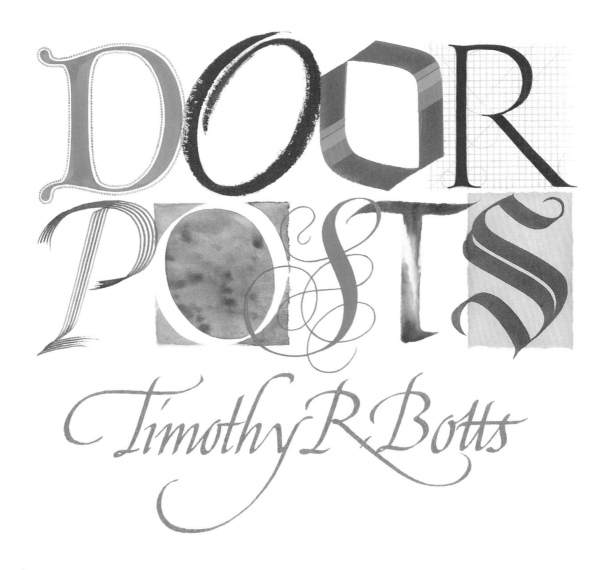

DOOR POSTS

Timothy R. Botts

TYNDALE HOUSE PUBLISHERS, INC.
WHEATON, ILLINOIS

D O O R P O S T S

All Scripture references are
from *The Living Bible*,
copyright 1971 by
Tyndale House Publishers

Library of Congress
Catalog Card Number 86-50328
ISBN 0-8423-0595-5
Copyright 1986
by Timothy R. Botts
All rights reserved
Printed in the
United States of America
95 94
12 11 10 9

To the memory of

ARNOLD BANK

whose enthusiasm for letters

was contagious

And to my wife

NANCY

who loves me

DOORPOSTS were the places where the early Hebrews wrote the commandments of God in order to be constantly reminded of them. . . .

This calligraphic project began in January of 1984 as a New Year's resolution to read through the entire Bible. Whenever I came to a passage that was particularly meaningful to me, I entered it into a sketchbook.

My own calligraphic approach is to express the meaning of the words by the way I write them. Color, weight, texture, size, position, and letter style are some of the means to this end.

Perhaps I need to say something about the text itself, which is from *The Living Bible.* Equivalent thoughts from the original ancient languages of Hebrew and Greek were set down in our current vernacular. The result is a highly emotive style that contributed greatly to my understanding.

In my own teaching of calligraphy, I have stressed what I consider foremost: listening to the text. As Rudolf Koch put it, "The calligrapher is the servant, the master is the text." And no other text is quite like this one.

It was natural for me to incorporate the basic elements of my art form, the letters of the alphabet, into this first piece. Each letter is a different color to represent the wonderful variety found in creation, which is a constant source of inspiration to my work. This verse challenges me, as one who recreates after God, to be a craftsman who strives for excellence.

Then God looked over all that he had made
and it was excellent in every way

A B C D E
F G H I J K L
M N O P Q
R S T U V
W X Y Z

GENESIS 1:31

The personality of God came through powerfully to me as I read these verses. I was struck by the great contrast of emotion between the two parts; so I played a harsh Gothic hand against a flourishing italic to illustrate the two extremes. It occurred to me as I thought about these words that it really matters to God how I live.

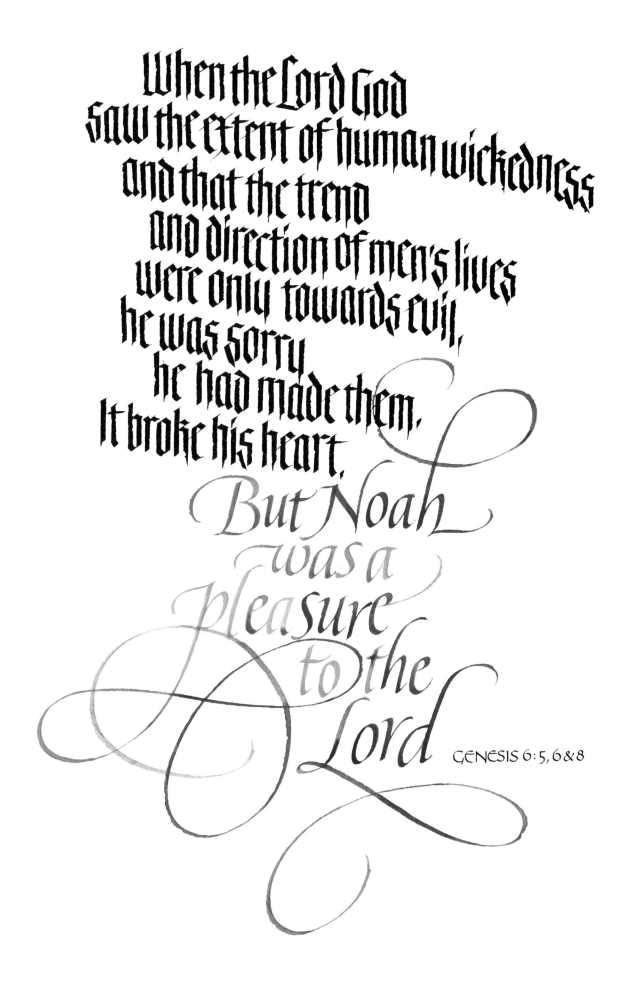

When the Lord God
saw the extent of human wickedness
and that the trend
and direction of men's lives
were only towards evil,
he was sorry
he had made them.
It broke his heart.
But Noah
was a
pleasure
to the
Lord

GENESIS 6: 5, 6 & 8

The roman capitals in this piece are similar to those cut in stone nearly two thousand years ago. The permanence of this method of inscribing has provided the basis for our Western writing today.

In a similar way, the Ten Commandments are the moral foundation of our civilization. The lightning between the verses is a reminder to me that God is to be taken seriously.

I AM JEHOVAH YOUR GOD

WHO LIBERATED YOU FROM YOUR SLAVERY IN EGYPT
YOU MAY WORSHIP NO OTHER GOD THAN ME YOU SHALL NOT MAKE YOURSELVES ANY IDOLS YOU SHALL NOT USE THE NAME of JEHOVAH YOUR GOD IRREVERENTLY REMEMBER TO OBSERVE THE SABBATH AS A HOLY DAY HONOR YOUR FATHER AND MOTHER YOU MUST NOT MURDER YOU MUST NOT COMMIT ADULTERY YOU MUST NOT STEAL YOU MUST NOT LIE YOU MUST NOT BE ENVIOUS of YOUR NEIGHBOR

FROM
EXODUS 20:2-17

*The everyday writing style
done with a Japanese brush
represents the leisure-loving,
independent people we are.
The absence of any regularity
of size, proportion, or spacing
in the script runs in direct
contrast to the carefully
disciplined strokes of the
majestic roman forms.*

I AM THE LORD

from Leviticus 22:31 & 32

Sometimes a single word triggers an entire way of arranging a piece. Can you sense the radiation of the golden flourishes?

In contemplating the idea of a radiating face, I discovered some new strokes that I never would have thought of otherwise. This suggests to me that the often mysterious creative process needs content or information as a springboard for new ideas.

May the Lord
bless and protect you;
may the Lord's face
radiate with joy
because of you;
may he be gracious to you,
show you his favor,
and give you his peace.

NUMBERS 6 : 24 – 26

Like most parents, I'm concerned about how my kids grow up. This text reinforces the idea of writing down God's words in order to be constantly reminded of their wisdom.

To convey innocence, I used my untrained left hand. I tried to imitate a child's experimentation with colors, but I chose strong colors for key words to aid legibility.

Teach these commandments
to your children
and talk about them
when you are at home
or out for a walk;
at bedtime
and the first thing
in the morning.

Tie them on your finger;
wear them on your forehead
and write them
on the doorposts
of your house.

from DEUTERONOMY 6:7-9

*The freshness of the word
<u>enthusiastically</u> in place of the
old phrase "with all your
might" caught my
imagination. Notice that the
repetition of the word is not a
precise duplication. That
would be too mechanical.
Rather, it is a device to create
movement and life on the
page.*

*I wanted this rendering to
be an expression of my own
enthusiasm for loving and
serving God.*

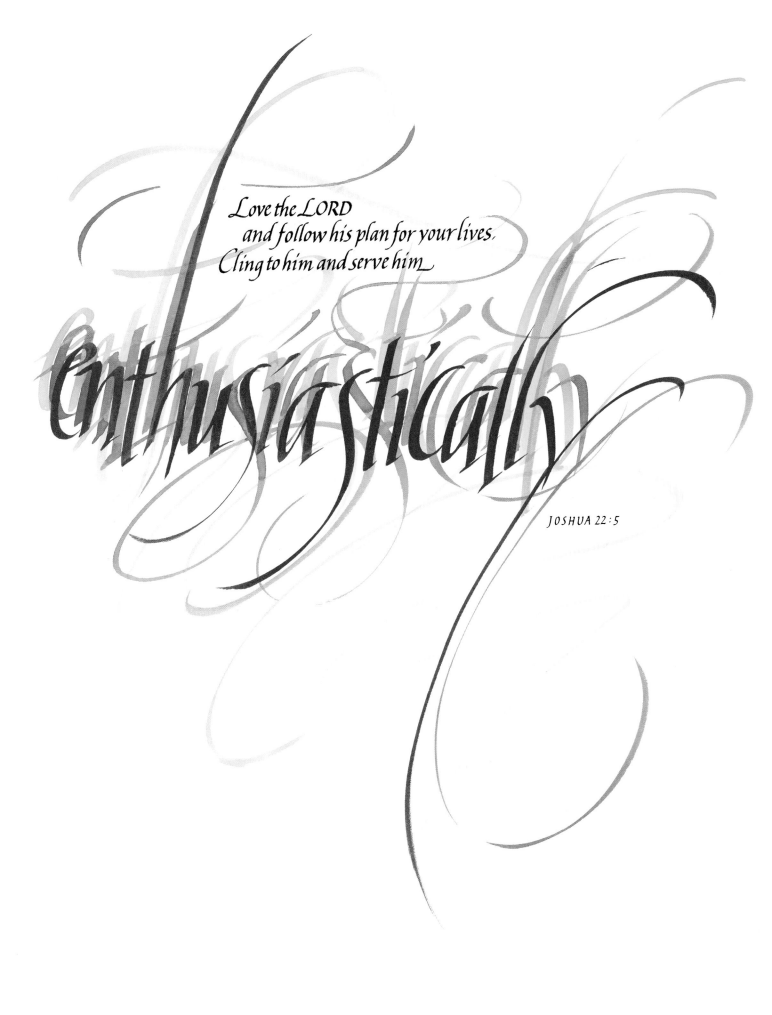

Love the LORD
and follow his plan for your lives.
Cling to him and serve him

enthusiastically

JOSHUA 22:5

By having these words fill so much of the page, I hoped to achieve a visual hyperbole equivalent to the supernatural strength of Samson. The one statement makes use of very bold Gothic forms, while the other counterposes a light, airy italic form. The latter symbolizes to me God's Spirit, someone unseen but whose movement is evident—like the wind.

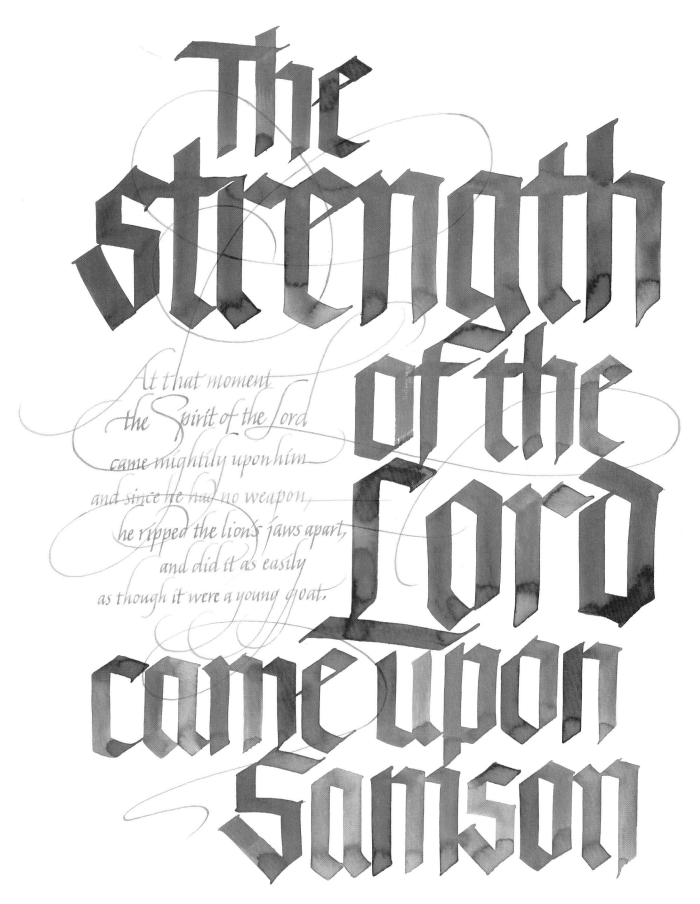

The strength of the Lord came upon Samson

At that moment the Spirit of the Lord came mightily upon him and since he had no weapon, he ripped the lion's jaws apart, and did it as easily as though it were a young goat.

JUDGES 14 : 6 & 15 : 14

The formal symmetry of this piece, not generally characteristic of my work, seemed, nevertheless, the most appropriate here. Its compasslike pattern represents this beautiful statement of commitment often made between a man and a woman.

I used pen manipulation for the compass design, gradually turning the pen 90 degrees from its broad edge to a point. This contemporary use of the pen departs from most historical examples of flat-pen writing in which the pen is consistently held at the same angle.

I want to go
wherever you go,
and to live
wherever you live;
your people
shall be my people,
and your God
shall be my God.

RUTH 1 : 16

The word <u>showered</u> invoked a
whole new variation of italic
letters for me. They had to be
soft-edged, gentle, and
descending in their movement.
The freedom I have as a
calligrapher allowed me to do
what no typesetter can do
easily—change letter size and
position to communicate
something organic and filled
with emotion or to emphasize
certain phrases over others.

O Lord God,
why have you
showered your blessings
on such an insignificant
person as I am?
Such generosity is far beyond
any human standard!
Oh, Lord God!
What can I say? For you know
what I am like! You are doing
all these things just because
you promised to and
because you want to.

from 2 SAMUEL 7:18-21

My piano-teaching grandfather once told me how important it was that I expand my repertoire of songs to play for people. I think I have done better with the number of letter styles I can do; so here I am showing them off.

I enjoyed creating an impression of something of which no visual record remains. Just as decorating details of a room often go unobserved, I ran these words together to create an atmosphere, rather than a literal representation. But like Solomon's craftsmen, my work can only hint at the Creator's glory.

O LORD · I HAVE BUILT YOU A LOVELY HOME ON EARTH · A PLACE FOR YOU TO LIVE FOREVER

LILY SHAPED CAPITALS

Designs of Rosebuds and Open Flowers

BRONZE-CHAIN-DESIGNED LATTICES BRONZE CHAIN-DESIGNED LATTICES

CEDAR PANELING

Palm Trees

CARVED LIONS

FOUR HUNDRED POMEGRANATES IN TWO ROWS IN TWO ROWS

TWELVE BRONZE OXEN standing tail to tail

three facing North

three south

three west and three east

wreath decorations wreath decorations wreath decorations wreath decorations

solid gold utensils & furniture

figures of angels

BUT is it possible that God would really live on earth? Why even the skies and the highest heavens cannot contain you, much less this temple I have built! from 1 KINGS 6-8

Here is what I was thinking:
a tall evergreen forest reaching
to the sky. The lines of the
music staff and the sprinkling
of gold complete the verb.
 I compressed the letters in
order to get the phrase on one
line and at the same time
convey respectful worship. It
makes me want to join in!

Let the trees in the woods sing for joy before the Lord

1 CHRONICLES 16 : 33

We had a building project on the drawing board at the time I read this verse, which really encouraged me as we met with the architect and the bank. That frightening feeling of having taken on something bigger than you've ever handled before—that is what inspired the giant framework of capital letters. The smaller letters are tucked in between to represent the many little details that also demand attention.

DON'T BE
FRIGHTENED
BY THE SIZE
OF THE TASK

BE
STRONG
AND
COURAGEOUS
AND
GET
TO
WORK
FOR
THE
LORD
MY
GOD
IS
WITH
YOU
HE
WILL
NOT
FORSAKE
YOU

HE
WILL
SEE
TO
IT
THAT
EVERY
THING
IS
FINISHED
CORRECTLY

1 CHRONICLES 28:20

God's power.

Our small planet.

I chose my largest and
smallest brushes to convey the
awesome contrast. This is an
example of how the character
of brush strokes can express
different emotions: thunder
versus calm.

I loaded an ordinary house
painting brush on both sides
with different colors that
merged in the middle of the
strokes to form a third color.

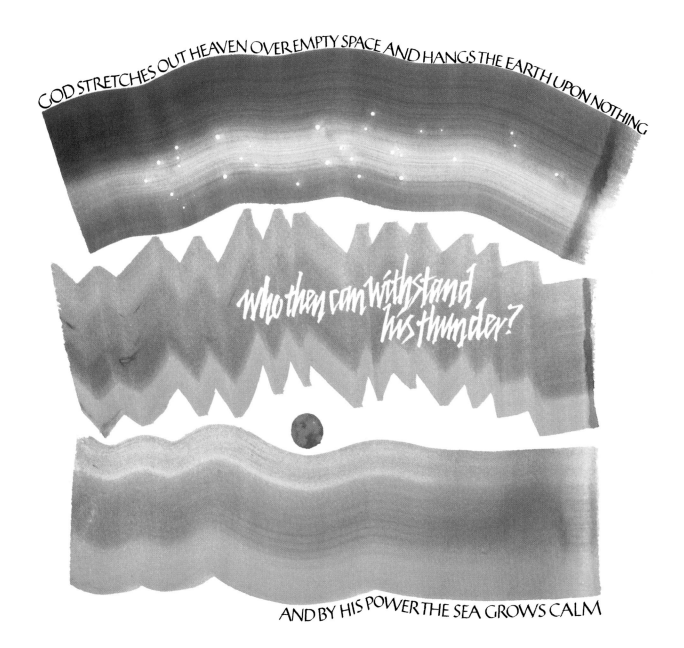

GOD STRETCHES OUT HEAVEN OVER EMPTY SPACE AND HANGS THE EARTH UPON NOTHING

who then can withstand his thunder?

AND BY HIS POWER THE SEA GROWS CALM

JOB 26 : 7, 12 & 14

Light reveals color, which is why I overlapped the primaries to form a full range of hues. The brush and the pen were twisted to make the spiked, raylike endings of the letters. These letters, in turn, induced me to write perpendicular lines, suggestive of the emanating quality of light.

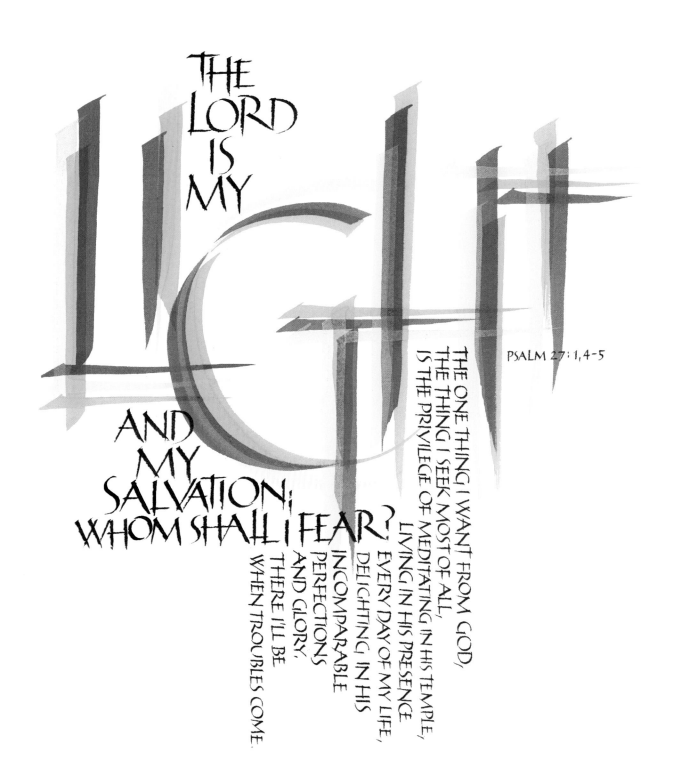

THE
LORD
IS
MY
LIGHT
AND
MY
SALVATION;
WHOM SHALL I FEAR?

PSALM 27:1,4-5

THE ONE THING I WANT FROM GOD,
THE THING I SEEK MOST OF ALL,
IS THE PRIVILEGE OF MEDITATING IN HIS TEMPLE,
LIVING IN HIS PRESENCE
EVERY DAY OF MY LIFE,
DELIGHTING IN HIS
INCOMPARABLE
PERFECTIONS
AND GLORY.
THERE I'LL BE
WHEN TROUBLES COME.

For many years, the varied cultures of the world with their costumes, flags, crafts, and writing systems have fascinated me. Finding the selection of the right art for each letter was a challenge, since I was looking for symbols that fit the natural shapes of the letterforms I was dealing with. Before arranging them, I had to consider the overall distribution of color and the varying degrees of complexity in the forms.

The result for me is a type of "united nations" with the worship of our Creator the unifying force.

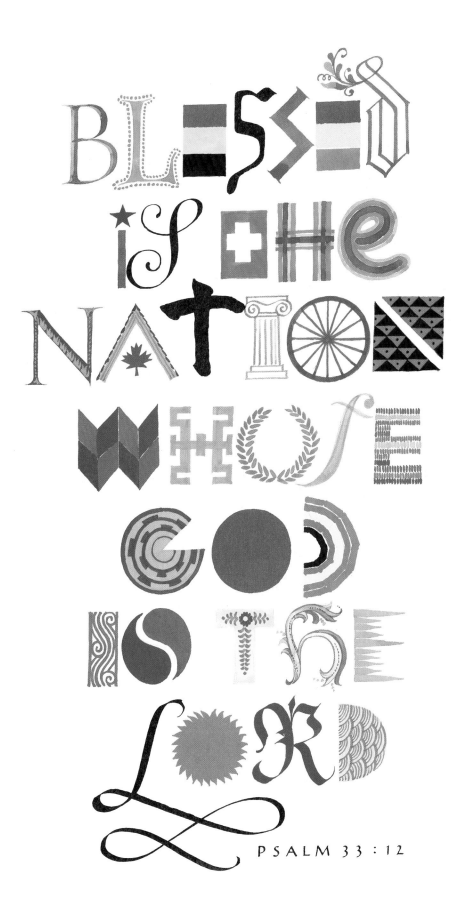

BLESSED IS THE NATION WHOSE GOD IS THE LORD

PSALM 33 : 12

The sensitive emotion of the
first verse contrasts with the
bold pronouncement of faith
in the second. The second
phrase made me think of the
trust of a little child; so I
wanted to write it like one.
Great fun!

Note the changes in color,
writing speed, and size that
help express this.

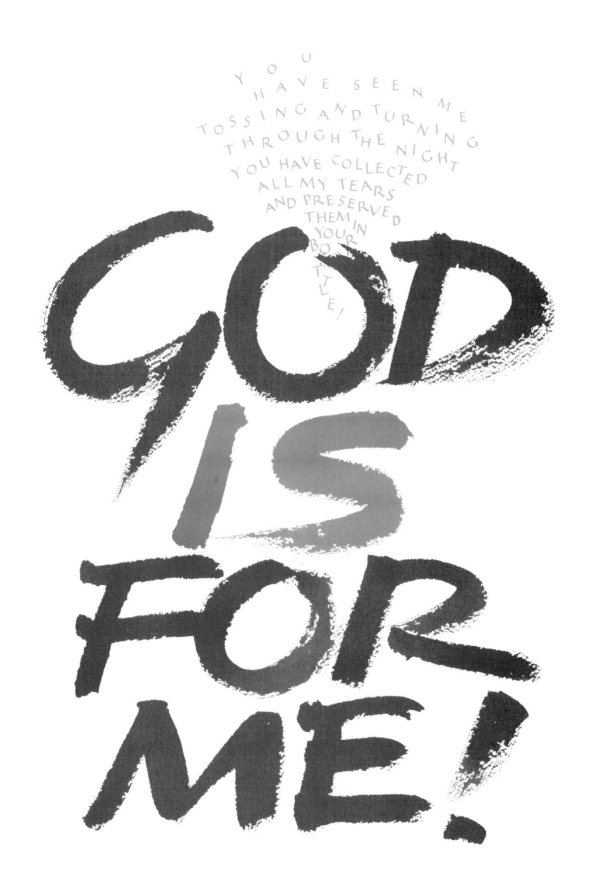

YOU HAVE SEEN ME TOSSING AND TURNING THROUGH THE NIGHT YOU HAVE COLLECTED ALL MY TEARS AND PRESERVED THEM IN YOUR BOTTLE!

GOD IS FOR ME!

from PSALM 56 : 8-9

Precious, a word we seldom use in our vocabulary. Maybe that is because we concentrate so much of our energy on things that are replaceable or disposable. But this beautiful statement brought to mind the analogy that people are like precious stones of different colors.

Each word after the first phrase was done with more water added to my pen. I wanted the words to seem whispered; so their size on the page is deliberately small to convey a sense of intimacy.

His
loved ones
are
very precious
to him
and
he does
not
lightly
let
them
die.

PSALM 116:15

Though my own family is not
as large as that suggested by
the surrounding border, I
thought about joyful times of
eating around the table with
extended family or friends.
My Pennsylvania Dutch
background and my interest
in fraktur ornamentation
probably come through here.
The traditional simplicity of
this piece is my personal
endorsement of the good "old-
fashioned" values that these
verses embrace.

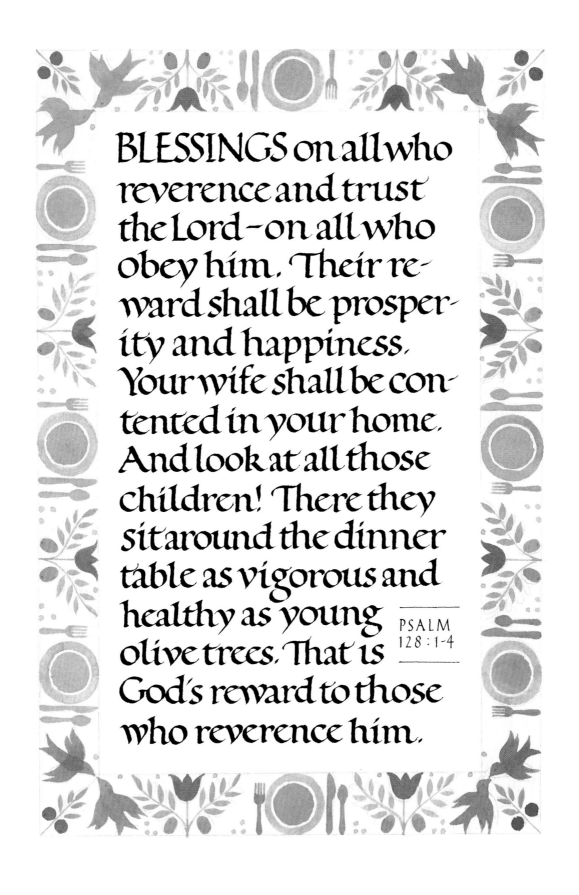

BLESSINGS on all who reverence and trust the Lord—on all who obey him. Their reward shall be prosperity and happiness. Your wife shall be contented in your home. And look at all those children! There they sit around the dinner table as vigorous and healthy as young olive trees. That is God's reward to those who reverence him.

PSALM
128:1-4

It was hard to choose from all the psalms! I included this one because it seems to present God's opinion about a big issue of our time: abortion.

Having always admired the patience of someone knitting, I determined to discipline myself to write every other letter in the two classic baby colors. The less common style of writing—Irish half-uncial— seemed the right choice to convey a slow rhythm.

You made all the delicate inner parts
of my body, and knit them together
in my mother's womb, thank you
for making me so wonderfully complex,
it is amazing to think about,
your workmanship is marvelous,
and how well I know it, you were there
while I was being formed in utter seclusion,
you saw me before I was born and
scheduled each day of my life
before I began to breathe, everyday
was recorded in your book. Psalm 139:13-16

This proverb reflects the very practical nature of this biblical book. It is amazing that such common sense has been around for twenty-three hundred years and yet some of us still operate without its advice. I constructed the initial capital <u>A</u> on a graph background to emphasize my own need to spend time at the drawing board.

PROVERBS 24 : 3-4

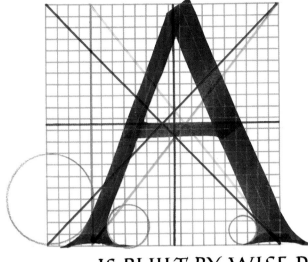

ANY ENTERPRISE
IS BUILT BY WISE PLANNING
BECOMES STRONG
THROUGH COMMON SENSE
AND PROFITS
WONDERFULLY
BY KEEPING
ABREAST OF
THE FACTS

A quilt seemed to be the
natural background for this
verse. Unlike most of the other
instances of roman in the
book, these letters were
"drawn" with a pointed
brush, rather than written
with the flat pen. The result,
I hoped, would mirror the less
sophisticated but no less
beautiful quality of many
handmade quilts.

ECCLESIASTES 4:11

These verses suggest two aspects of romance that should be present in a healthy marriage: passion and commitment. I tried to express the passion of love by the uncontrolled waves of italic lettering with its tentaclelike flourishes. On the other hand, a commitment to love is repeated in the circle, representing constancy and the need for both partners to enter into the pact.

Many waters cannot quench the flame of love. Neither can the floods drown it. If a man tried to buy it with everything he owned, he couldn't do it.

I AM MY BELOVED'S AND MY BELOVED IS MINE · I AM MY BELOVED'S AND MY BELOVED IS MINE · I AM MY BELOVED IS MINE · I AM MY BELOVED'S AND MY BELOVED IS MINE

SONG OF SOLOMON 6:3 & 8:7

Since I work with inks and pigments, I know what it is like to stain my clothes. That may be why this aspect of the verse captured my imagination.

It was difficult for me to stain and soil my artwork intentionally, until I realized that I was dealing with reality. A pretty picture had to give way to truth.

The red lettering near the end was done with the broken end of a twig.

Come, let's talk this over,
says the Lord;
no matter
how deep
the stain of
your sins,
I can take
it out
and make
you as clean
as freshly
fallen
snow.
Even
if you are stained
as red as crimson,
I can make you
white as
wool.

ISAIAH 1:18

Torn Japanese rice paper was
used here to convey the
torment of the prophet's heart.
I worked with a brush because
my steel pens tend to catch on
this type of writing surface.
Besides, all flat-pen styles
seemed too formal.

The colors are an
experiment in incongruity,
like the present world picture
where there are seemingly no
resolutions.

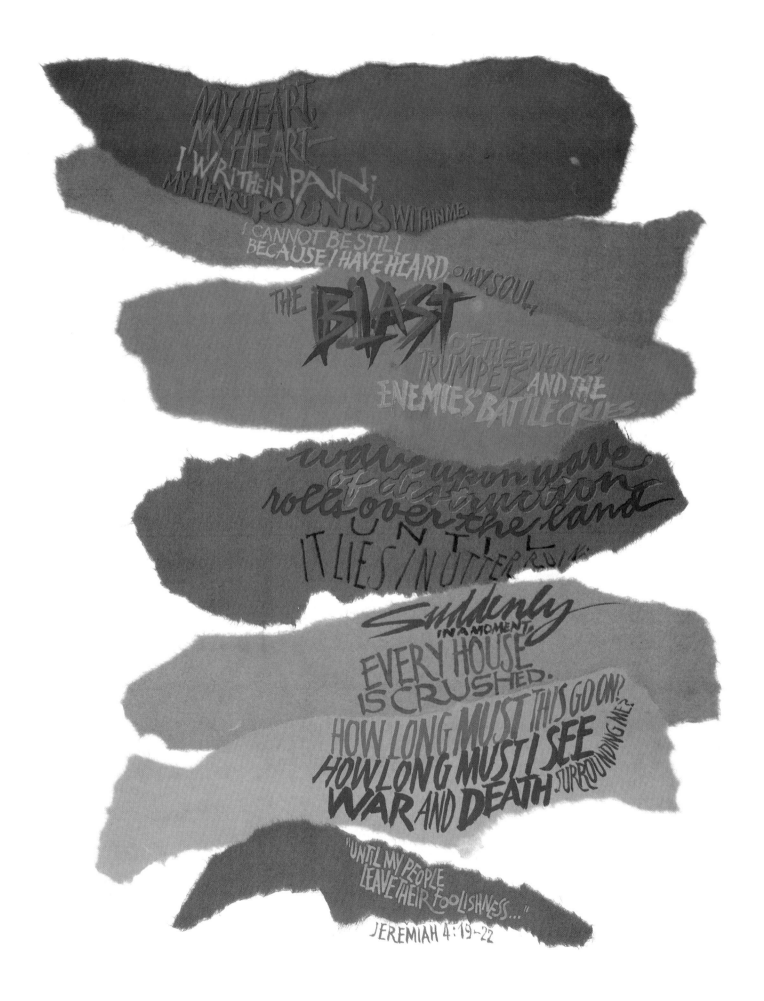

MY HEART,
MY HEART—
I WRITHE IN PAIN;
MY HEART POUNDS WITHIN ME.
I CANNOT BE STILL
BECAUSE I HAVE HEARD, O MY SOUL,

THE BLAST
OF THE ENEMIES'
TRUMPETS AND THE
ENEMIES' BATTLE CRIES

wave upon wave
of destruction
rolls over the land
UNTIL
IT LIES IN UTTER RUIN.

Suddenly
IN A MOMENT,
EVERY HOUSE
IS CRUSHED.
HOW LONG MUST THIS GO ON?
HOW LONG MUST I SEE
WAR AND DEATH SURROUNDING ME?

"UNTIL MY PEOPLE
LEAVE THEIR FOOLISHNESS..."

JEREMIAH 4:19-22

One day I came upon a
fascinating book entitled
Book of a Thousand Tongues.
It had the same Bible
passages printed in as
many languages as the title
implies.

Loving letters as I do, I was
captivated by the many
writing systems, each reflecting
the art of its own particular
culture. I decided to dedicate
this piece to those who work
on the most widely translated
book in the world and whose
motivation is, no doubt, the
same as Jeremiah's call.

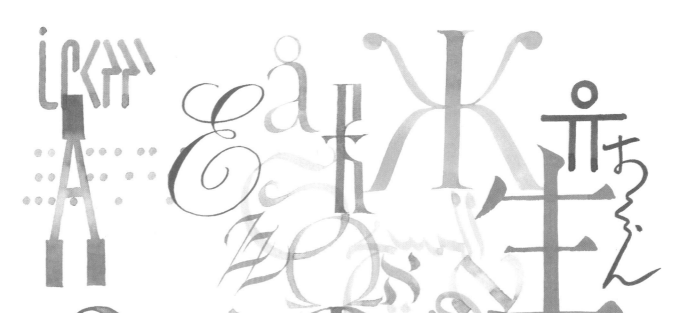
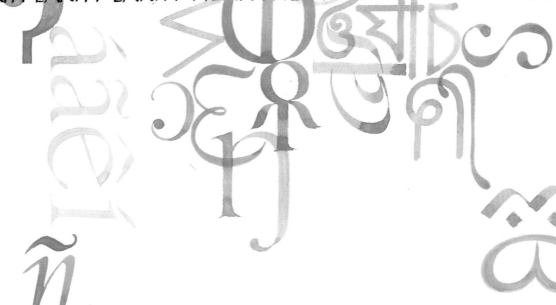

O EARTH · EARTH · EARTH · HEAR THE WORD OF THE LORD · JEREMIAH 22·29

This is an attempt to capture on paper a glimpse of the wonderful vision Ezekiel was permitted to have. Can you feel the hardness of the sapphire stones contrasting with the fluidity of the flaming words?

Only the impact of a true vision could cause the writer to close with his face downward on the ground!

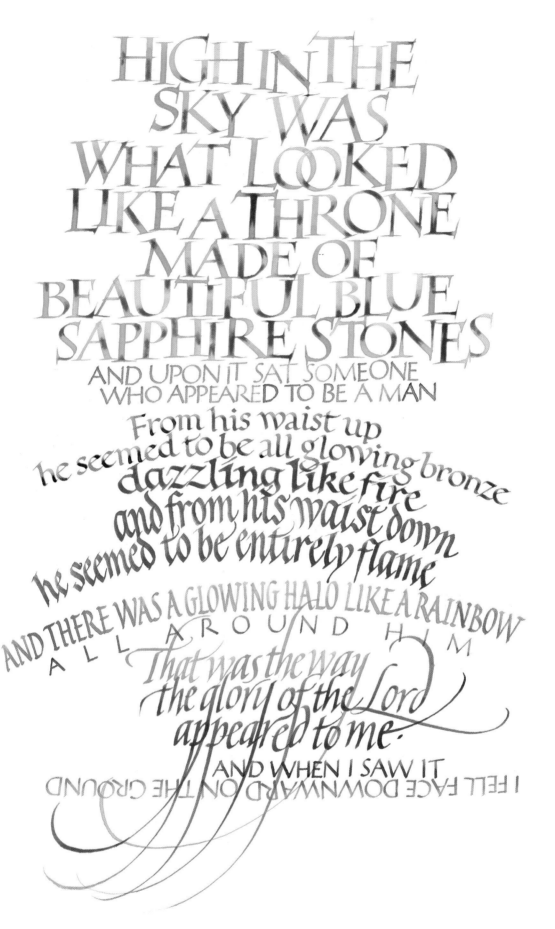

HIGH IN THE
SKY WAS
WHAT LOOKED
LIKE A THRONE
MADE OF
BEAUTIFUL BLUE
SAPPHIRE STONES
AND UPON IT SAT SOMEONE
WHO APPEARED TO BE A MAN

From his waist up
he seemed to be all glowing bronze
dazzling like fire
and from his waist down
he seemed to be entirely flame
AND THERE WAS A GLOWING HALO LIKE A RAINBOW
ALL AROUND HIM
That was the way
the glory of the Lord
appeared to me.
AND WHEN I SAW IT
I FELL FACE DOWNWARD ON THE GROUND

EZEKIEL 1:26-28

Shadrach, Meshach, and Abednego—the three heroes of this story—appear here as nearly illegible flames to symbolize their willingness to sacrifice their lives for the sake of the honor of God's name.

To be faithful to the content, I decided not to let the flames below touch the words above. This firm vertical direction stands in sharp contrast to, and in spite of, the undulating flames seeking to engulf them.

The fire hadn't touched them— not a hair of their heads was singed;

their coats were unscorched, and they didn't even smell of smoke!

FOR NO OTHER GOD CAN DO WHAT THIS ONE DOES.

Shadrach Meshach Abednego

O NEBUCHADNEZZAR,
We are not worried about what will happen to us.
If we are thrown into the flaming furnace,
OUR GOD IS ABLE TO DELIVER US,... BUT IF HE DOESN'T...
WE WILL NEVER UNDER ANY CIRCUMSTANCES SERVE YOUR GODS
OR WORSHIP THE GOLDEN STATUE YOU HAVE ERECTED...
They were willing to die rather than serve or worship
any god except their own.

from DANIEL 3:16-18 & 27-29

This warning by the Prophet Joel seemed to call for a harsh Gothic and angular italic. The radiating lines surrounding the primary text were inspired by the idea of making an about-face. Color changes in the lines further contributed to a sense of turning. The regimented symmetry of the largest words illustrates the way my own attention was arrested by this message.

The day
of the judgment
of the Lord
is an awesome,
terrible thing.
Who can
endure it?

from the prophet JOEL 2:11-13

"Turn to me now, while there is time. Give me all your hearts. Come with fasting, weeping, mourning. Let your remorse tear at your hearts and not your garments." Return to the Lord your God, for he is gracious and merciful, he is not easily angered, he is full of kindness and anxious not to punish you.

These words deeply affected me as I allied myself with the musicians who made their music for worship. I, too, have made offerings of art, which some friends have even called lovely. But they are futile without my personal attention to justice.

I used colored pencils to make the confined panes of color between words in the first statement. In the second verse I took the same colors and allowed them to break loose!

I HATE YOUR SHOW AND PRETENSE
YOUR HYPOCRISY OF 'HONORING'
ME WITH YOUR RELIGIOUS FEASTS
AND SOLEMN ASSEMBLIES I WILL
NOT LOOK AT YOUR OFFERINGS OF
PEACE AWAY WITH YOUR HYMNS
OF PRAISE THEY ARE MERE NOISE
TO MY EARS I WILL NOT LISTEN
TO YOUR MUSIC NO MATTER
HOW LOVELY IT IS

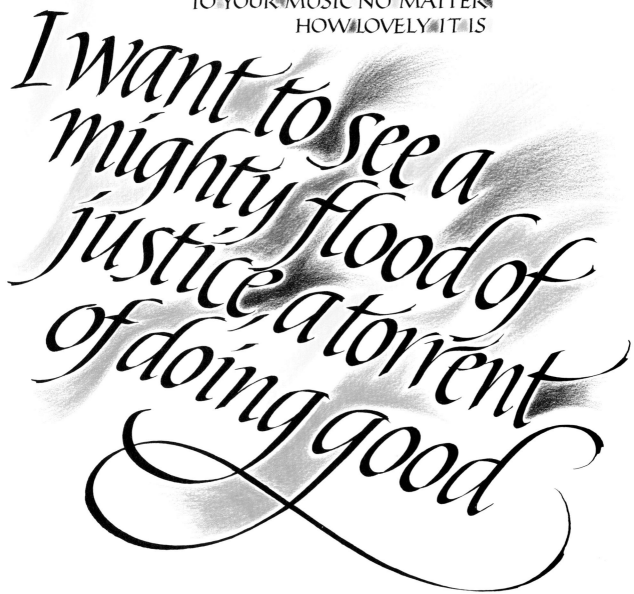

I want to see a
mighty flood of
justice, a torrent
of doing good

FROM AMOS 5:21-24

*I felt the claim God has
on a person's life in this
remarkable account. Half-
uncial writing once again
seemed appropriate because in
comparison to other historical
hands it appears quite lowly
and squat—not unlike the
position to which Jonah was
brought.*

*If you think you see the fish
in the waves, you have a good
imagination!*

How the LORD had arranged
for a great fish to swallow Jonah.
And Jonah was inside the fish
three days and three nights.
he was running away from the LORD.

In my great trouble I cried to the LORD
and he answered me;
from the depths of death
I called,
and LORD, you heard me!

When I had lost all hope,
I turned my thoughts
once more to the LORD.

And the LORD ordered the fish
to spit up Jonah
on the beach,
.and it did.

from JONAH 1:9,17; 2:2,7 & 10

Here I used seven pen changes, upward in size, to express the passage of time alluded to. How amazing that Micah penned these words seven centuries before Christ's birth in Bethlehem!

O BETHLEHEM
EPHRATHAH
YOU ARE BUT A
SMALL JUDEAN VILLAGE
YET YOU WILL BE
THE BIRTHPLACE OF MY KING
WHO IS ALIVE
FROM EVERLASTING
AGES PAST

MICAH 5:2

Here I wanted to express
fullness and glory. Repetition
and lavish flourishes seemed
appropriate. My first attempt
was a very free-formed piece
with no particular control or
harmony.

This present fan shape
seems like a small section of
the earth's rim. It is as if we
are seeing only a tiny part of
a much wider glory.

The time will come when all the earth is filled,
as the waters fill the sea,
with an awareness of the glory of the Lord.
The time will come when all the earth is filled,
as the waters fill the sea,
with an awareness of the glory of the Lord.
The time will come when all the earth is filled,
as the waters fill the sea,
with an awareness of the glory of the Lord.

HABAKKUK 2:14

With the message this strong and piercing, I broke the arches of the roman letters and exaggerated the serifs to look like thorns. Notice how the letters move up and down and are not parallel to each other. Two opposing colors on the color wheel for alternating letters were my final choice to represent two people at odds.

The Lord has seen
your treachery in
divorcing your wives
who have been faithful to you
through the years, the
companions you promised
to care for and keep.
You were united to your wife
by the Lord.
In God's wise plan, when
you married, the two of you
became one person in his sight.
Therefore guard your passions!
KEEP FAITH WITH THE
WIFE OF YOUR YOUTH.

from MALACHI 2 : 14-15

One limitation I placed upon
myself was to do all the work
for this book on white paper.
That would be a constant
amid the diversity of styles
and moods. However, when I
chose this first verse from the
New Testament, I really
wanted to use a black
background from which the
light could shine.

 Sandwiching the light
between two layers of darkness
solved the dilemma. The result
was a fresh way for me to
illustrate a very common
contrast.

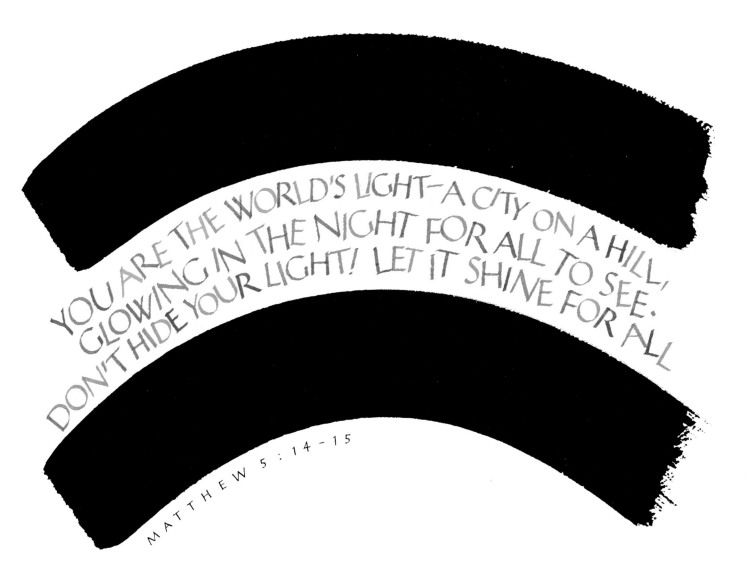

YOU ARE THE WORLD'S LIGHT—A CITY ON A HILL, GLOWING IN THE NIGHT FOR ALL TO SEE. DON'T HIDE YOUR LIGHT! LET IT SHINE FOR ALL

MATTHEW 5 : 14 – 15

Think of it: five thousand people fed with just a few loaves of bread and a handful of fish! I used common bookhand for the writing style because Jesus used ordinary elements to demonstrate his power to the masses.

An illustrative approach seemed to suit the narrative style here. The writing follows the contour of the art in order to unify the two parts.

... and Jesus
took the five
loaves and two fish,
looked up into the sky
and asked
God's blessing
on the meal,
then broke the
loaves apart
and gave them
to the disciples
to place before
the people.
And everyone
ate until full!
And when the
scraps were picked up
afterwards,
there were
TWELVE
BASKETFULS
LEFT OVER!

from MATTHEW 14:17-21

*A child's attempt at capital
letters contrasts here with the
elegance of the historical
roman forms and heightens
the irony of Jesus' statement.
The first style is a takeoff
from the work of Ben Shahn,
known especially for his lively
poster art in the fifties. Notice
that nearly all the thick and
thin parts of the letters are in
the wrong places. Do not
Jesus' teachings often run
counter to our normal ways of
operating?*

ANYONE
WHO HUMBLES
HIMSELF AS
THIS LITTLE CHILD
IS THE GREATEST
IN THE KINGDOM
OF HEAVEN

MATTHEW 18 : 4

I wanted the reader to feel with me the arduous search of the shepherd for his lost sheep. The primary message, written in large simplified roman capitals with generous space between the letters, gave me extra room to interweave the trail of small letters.

The terrain and the foliage are suggested with a natural sponge dipped in gouache. This opaque watercolor medium is what I have used for much of my color work in the book.

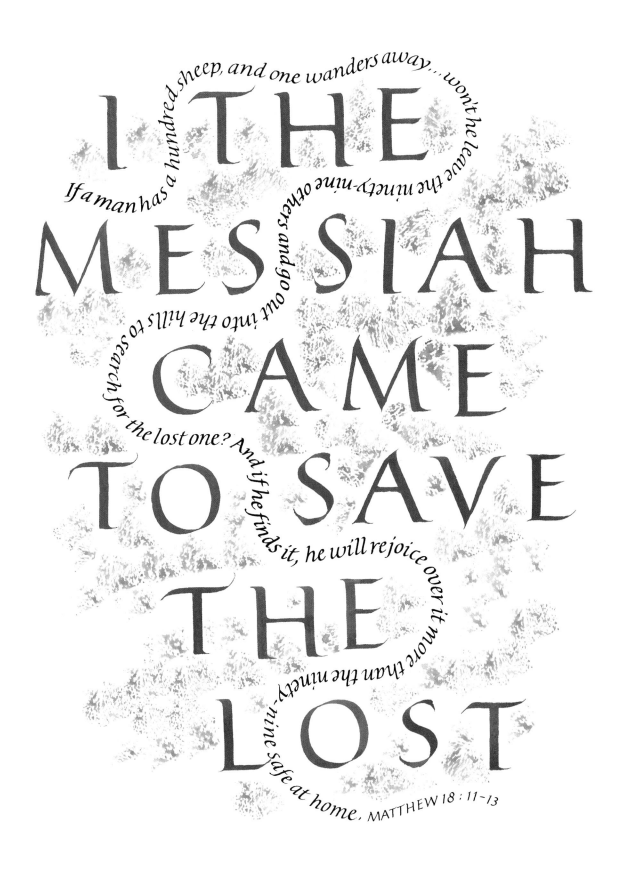

I THE MESSIAH CAME TO SAVE THE LOST

If a man has a hundred sheep, and one wanders away... won't he leave the ninety-nine others and go out into the hills to search for the lost one? And if he finds it, he will rejoice over it more than the ninety-nine safe at home. MATTHEW 18 : 11-13

A long text is often best broken down into its natural divisions. This way the material looks less cumbersome and hopefully gives the viewer incentive to read through the entire message. I chose the rough surface of watercolor paper to contribute to an earthy feel.

Listen!
A farmer decided to
sow some grain.
THE HARD PATHWAY
where some of the seed fell,
represents the hard hearts of some
of those who hear God's message.

The rocky soil
represents
the hearts of those
who hear the message with joy,
but ..., their roots don't go very deep....
as soon as persecution begins,
they wilt.

The thorny ground
represents the hearts of people who
listen to the Good News and receive it,
but the attractions of this world
crowd out God's message
from their hearts,

But the 'good soil'
represents the hearts of those
who truly accept God's message
and produce a plentiful harvest
for God.

from Mark 4 : 3, 14 - 20

I love when advertisers take a very small object and blow it up much larger than normal size for shock effect. So, here we have the eye of a needle with the words passing through like thread.

The "rustic" hand, because of its condensed form, allowed me to get many words on a line. I wanted to visually echo Jesus' hyperbole.

HOW HARD IT IS FOR THOSE WHO TRUST IN RICHES TO ENTER THE KINGDOM OF GOD. IT IS EASIER FOR A CAMEL TO GO THROUGH THE EYE OF A NEEDLE THAN FOR A RICHMAN TO ENTER THE KINGDOM OF GOD... THEN WHO IN THE WORLD CAN BE SAVED? WITHOUT GOD IT IS UTTERLY IMPOSSIBLE, BUT WITH GOD EVERYTHING IS POSSIBLE.

FROM MARK 10:24-27

The overlaid watercolor paper
was first wet and then painted
with a design loosely taken
from a Persian-style rug in
our home. Next, I rinsed the
paper in water. After drying it,
I tore it in half.

The split symbolizes both
the curtain and the darkness.
They are supernatural signs to
me of the uniqueness of Jesus'
death and were the basis for
the Roman officer's testimony
of faith.

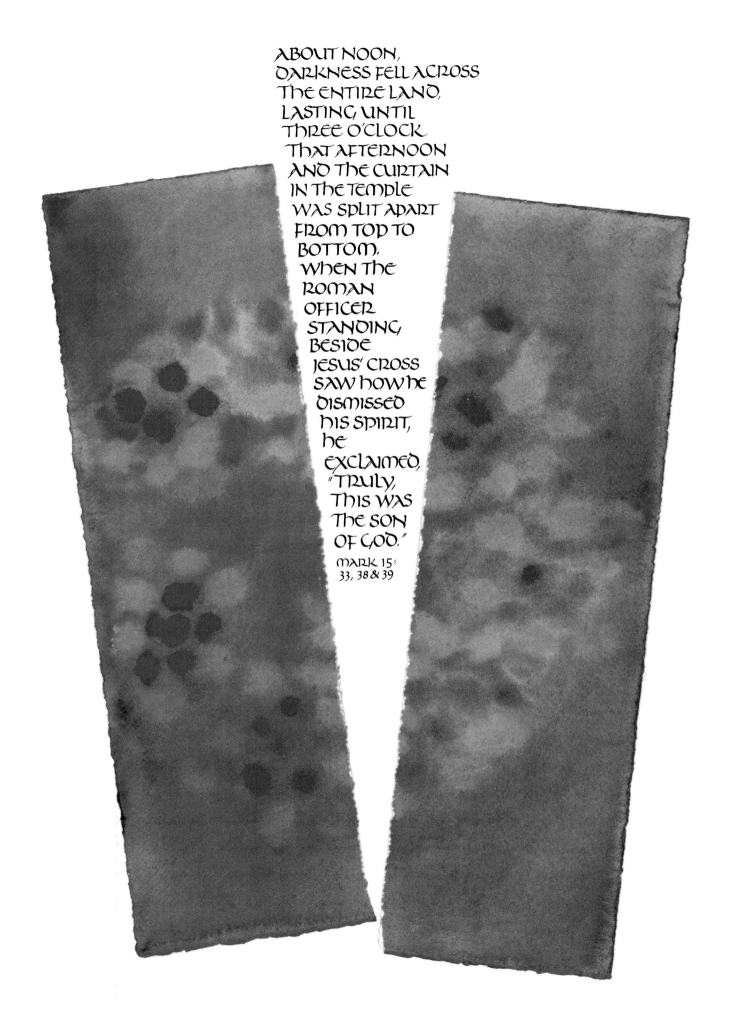

ABOUT NOON,
DARKNESS FELL ACROSS
THE ENTIRE LAND,
LASTING UNTIL
THREE O'CLOCK
THAT AFTERNOON
AND THE CURTAIN
IN THE TEMPLE
WAS SPLIT APART
FROM TOP TO
BOTTOM.
WHEN THE
ROMAN
OFFICER
STANDING
BESIDE
JESUS' CROSS
SAW HOW HE
DISMISSED
HIS SPIRIT,
HE
EXCLAIMED,
"TRULY,
THIS WAS
THE SON
OF GOD."

MARK 15:
33, 38 & 39

Seeing the Fourth of July
fireworks the night before was
a stimulus for my mental
image of the angels'
appearance. Certainly,
God's big announcement
must have been at least as
spectacular and exciting as
man's noisy celebration. And
even more frightening!

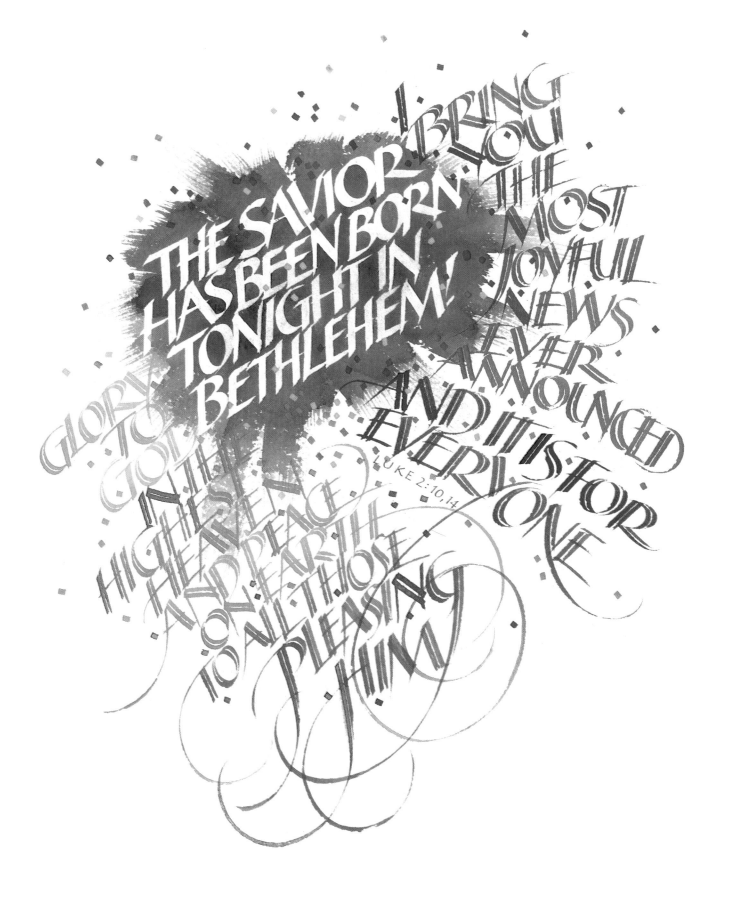

"I BRING YOU THE MOST JOYFUL NEWS EVER ANNOUNCED AND IT IS FOR EVERYONE! THE SAVIOR HAS BEEN BORN TONIGHT IN BETHLEHEM!"

GLORY TO GOD IN THE HIGHEST HEAVEN AND PEACE ON EARTH TO ALL THOSE PLEASING HIM

LUKE 2:10,14

The word <u>forgive</u> caught my attention in these two verses. The first was proclaimed by Jesus before he died; the second one, after he came back to life. I looked for a board with pronounced grain to make this print as graphic as possible.

My banner, though with different words, arches the cross, even as the cross upon which Jesus died had an inscription on top—The King of the Jews.

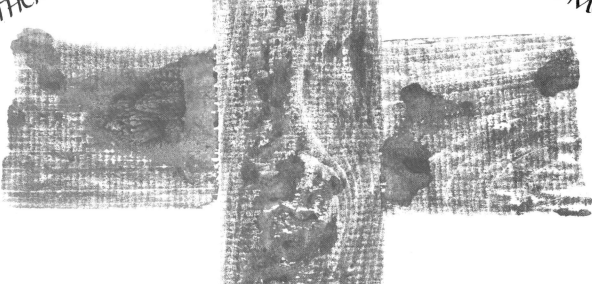

"FATHER, FORGIVE THESE PEOPLE," JESUS SAID,
"FOR THEY DON'T KNOW WHAT THEY ARE DOING."
THERE IS FORGIVENESS OF SINS FOR ALL WHO TURN TO ME,

LUKE 23:34; 24:47

Prints of my feet and the spatterings of an old toothbrush. They reflect here my need to get involved. I have always admired the service-oriented Mennonite people, some of whom still practice the ancient custom of foot-washing.

I worked on Japanese rice paper because it prints detail the best. But its absorbency makes it difficult to write on. I decided to accept this apparent limitation, with its resulting variety in the texture of the letters. One advantage is that it breaks the monotony created by so many capital letters.

SINCE I, THE LORD
AND TEACHER HAVE
WASHED YOUR FEET,
YOU OUGHT TO WASH
EACH OTHER'S FEET.
LOVE EACH OTHER
JUST AS MUCH
AS I LOVE YOU.
YOUR STRONG LOVE
FOR EACH OTHER
WILL PROVE TO THE
WORLD THAT YOU
ARE MY DISCIPLES.

FROM JOHN 13:14, 34 & 35

To do the word <u>peace</u>, I first
used a "resist" of rubber-based
liquid mask, which I brushed
on the paper. Then I applied a
watercolor wash over top.
When that dried, the mask
was easily rubbed off,
allowing the white of the
paper to show through.

In this way I hoped to
express an intangible that is
hard to explain but very much
present. Generous space
between letters in some of the
lines is a technique to slow
down and quiet the reader.

I AM LEAVING YOU WITH A GIFT:

PEACE

OF MIND AND HEART
AND THE PEACE I GIVE ISN'T FRAGILE LIKE THE PEACE THE WORLD GIVES
SO DON'T BE TROUBLED OR AFRAID

JOHN 14 : 27

A furious, spiraling stroke of a broad brush set the stage for this startling event. I chose a very fast italic joined as hand-writing to achieve a greater sense of spontaneity.

The flames represent the unified group gathered at Pentecost. Notice they slope with the letterforms as if blown by the same wind. My original sketch made use of gold ink for greater brilliance, but I had to abandon it because of the limitation of the printing process.

As the believers met together that day
suddenly there was a sound like the roaring of
a mighty windstorm in the skies above them
and it filled the house where they were meeting
Then, what looked like flames or tongues of fire appeared
and settled on their heads. And everyone present
was filled with the *Holy Spirit*
and began speaking in
languages they didn't know
for the Holy Spirit gave them this ability.

from ACTS 2 : 1 – 4

It is too bad we often miss the wonderful signs in nature that reveal the Creator behind it all. At first, I used a watercolor wash as a background for my writing. Then it occurred to me that it could represent the evidence Paul is challenging us to consider.

To make the background a piece to ponder, I relegated the writing to a less prominent position. I attribute this unconventional use of space to my having lived three years in Japan. While there, I enjoyed its spacious art within the ironic context of crowded conditions.

SINCE
EARLIEST
TIMES
MEN
HAVE
SEEN
THE
EARTH
AND
SKY
AND
ALL
GOD
MADE,
AND
HAVE
KNOWN
OF HIS
EXISTENCE
AND
GREAT
ETERNAL
POWER.
SO THEY
WILL
HAVE
NO
EXCUSE
WHEN
THEY
STAND
BEFORE
GOD
AT
JUDGMENT
DAY.

ROMANS 1:20

I am especially pleased about the way all the parts of this design fit together. This was the result of much planning and reworking.

Each different color and writing style represents a different experience or situation we face during the course of a lifetime. There is a parallel here: Tim Botts designed this page of letters; God is designing my life.

We know that all that happens to us is working for our good & we love God & are fitting into His plans

ROMANS 8:28

Challenged by the words "wonderful things never imagined," I set out to create letterforms and ornamentation unlike anything I had ever seen before. As in much of my work, I had to deal with the tension between legibility and creativity.

I wanted to delight the viewer visually so that he would work to discover the message. The unique shapes and forms are loosely based on an uncial form, with each successive letter considered in relation to the shape and space of the former.

No mere man has ever seen, heard or even imagined what wonderful things God has ready for those who love the LORD.

1 CORINTHIANS 2:9

To make a wonderful kind of tree that grows a variety of fruit—this was my goal. To help achieve that, I let the letters bounce up and down to suggest something organic and growing.

Just as physical fruit is totally dependent on the vine for its life and growth, the words in green are the power source for these character traits.

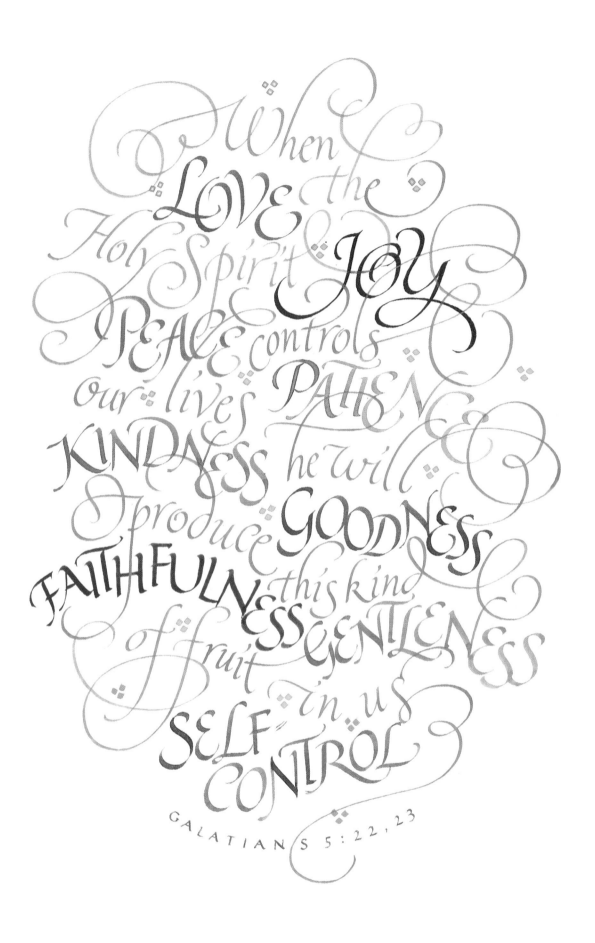

When the Holy Spirit controls our lives he will produce this kind of fruit in us

LOVE JOY PEACE PATIENCE KINDNESS GOODNESS FAITHFULNESS GENTLENESS SELF-CONTROL

GALATIANS 5:22,23

The image of an organism of depth and stability came to mind as I contemplated these words. I stretched my letters to reach deep down into the heart of the last phase. By writing these last words so large, yet subdued, I hoped to convey the sense of mystery and awe I felt in meditating on them.

I pray that Christ will be more and more at home in your hearts, living within you as you trust in him. May your roots go down deep into the soil of God's marvelous love; and may you be able to feel and understand... how long, how wide, how deep, and how high his love really is; and to experience this love for yourselves, though it is so great that you will never see the end of it or fully know or understand it. And so at last you will be filled up with

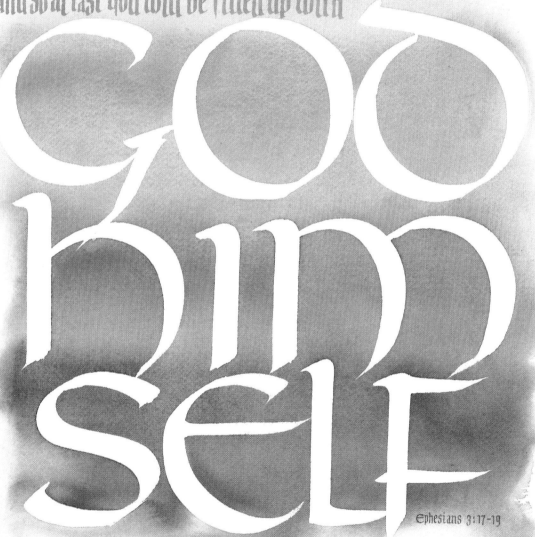

GOD HIMSELF

Ephesians 3:17-19

The upward thrust of this message gave me the idea of raising each successive letter. I included the laurel wreath because when these words were first written, laurel wreaths were popular awards for athletic victories. I wrote the lines in alternating colors for increased legibility and dynamism.

I AM STILL NOT ALL I SHOULD BE
BUT I AM BRINGING ALL MY ENERGIES
TO BEAR ON THIS ONE THING:
FORGETTING THE PAST AND LOOKING
FORWARD TO WHAT LIES AHEAD
I STRAIN TO REACH THE END OF THE RACE
AND RECEIVE THE PRIZE FOR WHICH GOD IS
CALLING US UP TO HEAVEN BECAUSE OF WHAT
CHRIST JESUS DID FOR US PHILIPPIANS 3:13-14

I was thinking about all of the phyla and species of creation when I embellished these letters. Since there is no space between the lines of words, I used the color changes in the background bars to visually separate them.

The negative space letters support the idea of Christ's being the power behind creation. Even though I do not see him, I see the evidence of what he does.

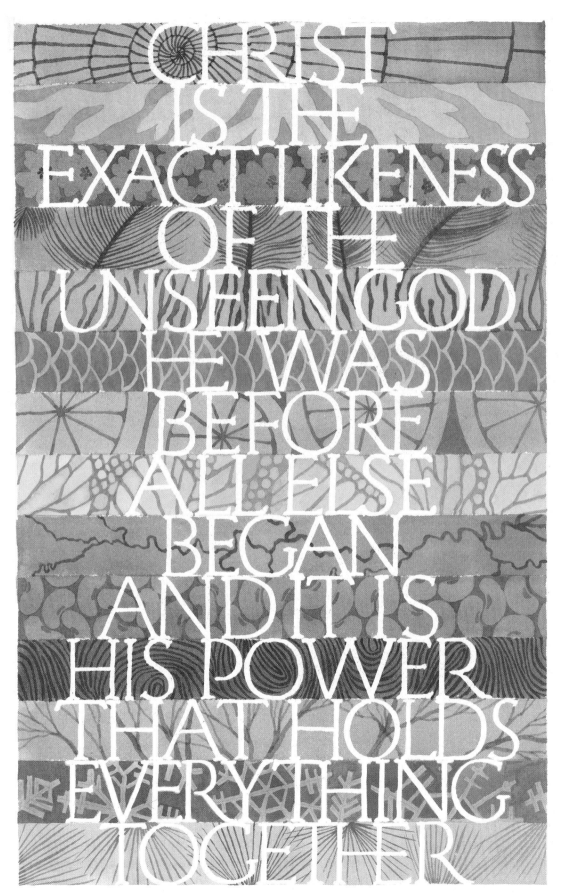

CHRIST
IS THE
EXACT LIKENESS
OF THE
UNSEEN GOD
HE WAS
BEFORE
ALL ELSE
BEGAN
AND IT IS
HIS POWER
THAT HOLDS
EVERYTHING
TOGETHER

from COLOSSIANS 1:15 & 17

This passage may well be the source of inspiration for the American folk hymn "I'll Fly Away." Except for the gentle undulation of the lines, I felt no need to visually interpret the message.

I simply wanted the emphasis to be on the extraordinary content. As I got close to the end of the passage, however, the words "with him forever" jumped out, making me realize that they perfectly capsuled everything else.

And now, dear brothers, I want you to know
what happens to a Christian when he dies
so that when it happens,
you will not be full of sorrow,
as those who have no hope.
For since we believe that Jesus died
and came back to life again,
we can also believe that when Jesus returns,
God will bring back with him
all the Christians who have died.

And the believers who are dead
will be the first to rise to meet the Lord.
Then we who are still alive
and remain on the earth
will be caught up with them in the clouds
to meet the Lord in the air
and remain with
him forever
So comfort and encourage each other
with this news.

1 THESSALONIANS 4:13, 14, 16-18

*Whatever quality my work
possesses I owe in great part
to the challenge of these words.
In the background are some of
the preliminaries through
which a calligrapher must go
before a finished piece of any
depth can emerge.*

Be a good workman, one who does not need to be ashamed when God examines your work

2 TIMOTHY 2:15

To make these letters, I held a Japanese brush without resting my palm on the paper. This position made it difficult to control the strokes. The result for me was an identification with pain that I wanted the reader also to feel.

Except for the strongest words in this verse, I avoided using pure color by going back and forth between complementaries, mixing them with varying amounts of water.

The speed of the writing, which was very slow, also contributed to the result.

Since
Jesus
himself
has now been
through
suffering
and temptation,
he knows
what it is like
when we suffer
and are tempted.
and he is
wonderfully
able to
HEBREWS 2:18 help
us.

Here the English roundhand style of writing accentuates the irony of this hard-hitting message. The cool formality contrasts sharply with the risk of involvement called for by the text.

I feel that my own work on this book is under indictment if it is not backed up by my active personal response to the needs of the people who flank me like the homey border.

If you have a friend who is in need of food and clothing and you say to him, "Well, good-bye and God bless you; stay warm and eat hearty," and then don't give him clothes or food, what good does that do?...

Faith that doesn't show itself by good works is no faith at all – it is dead and useless.

JAMES 2 : 15 - 17

Intermingling two messages seemed to work well here because that conveys several things about the content. Two contrasting genders, male and female, are represented by two writing styles. This counter-balancing creates more interest than if they were the same.

WIVES

HUSBANDS

Don't be concerned about

Be careful of your wives,

the outward beauty that depends

being thoughtful of their needs

on jewelry, or beautiful clothes,

and honoring them

or hair arrangement.

as the weaker sex.

Be beautiful inside,

Remember that you and your wife

in your hearts,

are partners in receiving God's blessings,

with the lasting charm

and if you don't treat her as you should,

of a gentle and quiet spirit

your prayers will not get

which is so precious to God.

ready answers.

1 PETER 3:3, 4 & 7

In my first draft of this, the colors were not in their correct relative balance. Because the word Is was in the deepest color, the phrase had turned into a question. Without changing the arrangement of the forms, I was able to correct this by color adjustment. I wanted to communicate a permeating expression of this definition of God.

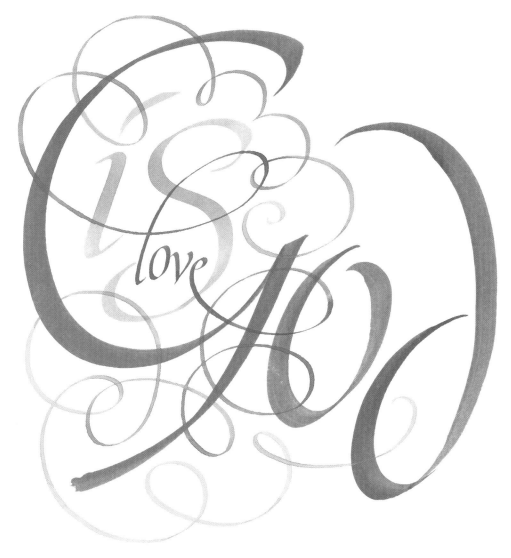

love

1 JOHN 4 : 8

I had the most fun here with the word <u>pearl</u>, where I dropped the primary colors into letters still wet from having been written with water. In one respect, the last piece is a disappointment because it is impossible to visualize a setting that exists in a dimension different from our present experience. Perhaps that is the advantage of a word picture—it is abstract enough for the imagination to take over.

In a vision...
I watched that wondrous city,
the holy Jerusalem,
descending out of the skies from God.
THE CITY ITSELF
WAS PURE, TRANSPARENT GOLD LIKE GLASS!
with

On each side
of the river
grew
Trees of Life,
bearing
twelve crops of fruit
each month;
the leaves
were used
for medicine
to heal the
nations.
There shall be
nothing
in the city
which is evil;
for the throne
of God
and of the Lamb
will be there...

jasper
sapphire
chalcedony
emerald
sardonyx
sardus
chrysolite
beryl topaz
chrysoprase
jacinth
amethyst
THE TWELVE GATES
WERE MADE OF
PEARL

And the city
has no need
of sun or moon
to light it,
for the glory
of God and of
the Lamb
illuminate it.
Its light will
light the nations
of the earth...
and
his servants
shall see his face;
These
words are
trustworthy
and true;
I am
coming soon!

from REVELATION 21 & 22